CALLIGRAPHY
for the Beginner

CALLIGRAPHY
for the Beginner

. . .

Tom Gourdie

A. & C. Black,
London.

First published in Great Britain in 1983
A&C Black Publishers Limited
38 Soho Square
London, W1D 3HB
www.acblack.com

Reprinted 1984, 1985, 1987, 1989, 1991, 1999, 2003, 2005, 2008

ISBN 978-0-7136-6715-8

A CIP record for this book is available from the British Library.

This book is produced using paper that is made from wood grown in managed, sustainable forests. It is natural, renewable and recyclable. The logging and manufacturing processes conform to the environmental regulations of the country of origin.

Cover design by James Watson

Printed in Great Britain by Bell & Bain Ltd., Glasgow

Calligraphy for the Beginner

is aimed at all who are just commencing this study.
You will find that the course has been carefully graded
and divided into fourteen stages, which if followed as
they are set out, will ensure that in time you will have
a reasonable working acquaintance of the craft.
We do not claim that in twenty four hours (or even
in a few weeks) you will be sufficiently skilled to com -
mercialise your new skill ~ a nonsensical claim by an
American teacher. Once interested, we suggest that you
put yourself in the hands of a reputable calligrapher
for professional guidance and instruction. You may
also wish to associate yourself as a lay member of the
British Society of Scribes and Illuminators and through
the Newsletter, get all necessary information regarding
courses and tutors. The lay member is particularly
catered for. Write to the Membership Secretary.

calligraphy
is beautiful!

TOOLS FOR THE CALLIGRAPHER, · especially for the beginner ·

THIS need not be an expensive hobby, for the tools required are few & inexpensive. To begin, all that is necessary is a pen-holder, nibs, ink, paper (including a lay-out pad) ruler, dividers and drawing board. The WILLIAM MITCHELL PEN-HOLDER and two reservoirs are sold on a card of BROAD LETTER-ING NIBS, ten in number, ranging in width from 1/32" to the broadest which is 1/8" (from No 6 to No 0). Lettering nibs are generally obtainable in two kinds only: (1) Left-oblique 卅 and (2) Square or straight cut 卅. If you are left-handed you may prefer to use the left-oblique nibs. Some of the names associated with lettering pens are, besides the William Mitchell brand, Gillot, Brause, Hunt, and, more recently, Nikko of Japan whose square-cut nibs are an almost exact copy of the William Mitchell ones and differ only in being slightly right-oblique. FOUNTAIN PEN LETTERING SETS with inter-changeable nib units are now available – the Rotring, Sheaffer 'No-Nonsense' and Platignum sets are particularly recommended. For much larger work you will need POSTER PENS, 1/4" to 1" wide, which may be of metal or of felt inserted into metal holders: ▭. Then there are special brushes called ONE-STROKE, beginning at 1/8" in width to as broad as you wish, which also produce thick and thin strokes. But TWO PENCILS, held together by an elastic band, are ideal for first practice for the double lines show if

the pen is being held correctly .

You may also try using a chisel-edged marker.

INK AND COLOUR. There are various brands of black fountain·pen ink suitable for lettering : Parker Permanent Black Quink, Sheaffer black & Waterman's black. Higgins American Indian ink is recommended for lettering pens and although it is a waterproof it does not readily clog but runs freely. You may make your own black ink by rubbing a Chinese ink·stick in a slab over which drops of water have been poured — the ink runs down into the little trough: . Of·course, the water must be distilled or be rain-water or freshly boiled. Contrary to what a certain pen manufacturer says, never use waterproof Indian ink in a fountain pen, even one they have specially designed for this purpose! This firm's black ink is also not recommended.

COLOURS should be made up from powder colour, ground down finely with mortar and pestle and mixed into a flowing state with water to which a drop or two of gum arabic has been added to prevent the colour being rubbed off when dry. Water colour (pan or tube) may also be used but ordinary coloured inks are not considered suitable for lettering. Chinese white poster colour suitably thinned with water, can be used to write on dark or tinted paper, but the pen must be kept clean and wiped regularly with a damp rag to prevent clogging. Where black inks have gone thick, they may be thinned down (for the most part) with distilled water.

OTHER REQUIREMENTS are a drawing board (half·imperial size will do), set-square, T·square, compasses, soft rubber, type·writer rubber (eraser), pencils and water colour

4

brushes, preferably fine sable. A good quality pen-knife is also necessary. With it one can make pens from cane and bamboo and it is also useful for erasing.

It is advisable to work with several sheets of paper under one's writing, and these may be taped down with masking tape. To prevent the paper you are working on, sliding about, fold a strip of paper to form a ledge and tape it into position just up from the bottom of the drawing board.

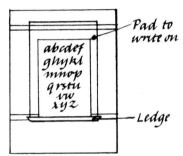

Pad to write on

abcdef ghykl mnop qrstu vw xyz

— Ledge

THE WORKTABLE should be about fore-arm high. With a lap-board supported by the edge of the table, it is possible to work very comfortably, without any strain whatever.

THE LIGHT should come from over the left-shoulder – a standard lamp with adjustable lights is essential, especially when one is involved with fine work.

HOLD THE PEN between the thumb and fore-finger and support it with the middle finger and in making the strokes let the hand (not the fingers) move the pen. Ordinarily, hold the pen pointed to the writing line at 45° ↖ so that the vertical and horizontal strokes are equally wide : ┼ ┼ . Do not try to twist your wrist on making circular strokes — a common fault with be-ginners ○○

Sitting, board on lap. Light from left.

The Roman Capital was perfected in the **A** reign of the Emperor Trajan and **B** is the found-ation of all our **C** historic alphabets.

The Carved Roman Capital led to the pen-made 'Square' Capital, then to the 'Rustic' Capital & so to the Uncial which in turn produced the Half-Uncial,

defgh

the first of the small-letter alph- abets. This gave way in time to the

ijklm

beautiful Carolingian book hand of the 9th & 10th centuries followed by the

nopqr

Gothic hands. The revived Caro- lingian hand in Italy in the

stuvw

14th & 15th centuries eventually produced the exquisite Italian Cursive hand.

The Block Capital of **X** today is based on the **Y** Roman Capital but has no varia- **Z** tion of stroke.

6

LETTERING

is everymans craft. Our instruction in it begins as soon as we go to school for BLOCK LETTERS based on ROMAN CAPITALS often introduce the teaching of handwriting.

But to raise it to a craft or to establish it as an art, lettering demands an understanding of the basic forms, their manipulation and arrangement which are things far removed from the Infant class-room.

For our study at this stage we need no more than a sheet of paper, a T-square and a pencil and, of-course, a drawing board – but a sheet of ruled paper will be quite sufficient to start with !

Here is the basic capital alphabet placed between three lines, the middle one serving a most useful purpose in enabling one to determine the proper drawing of the letters BPR, EF, HK, XY.

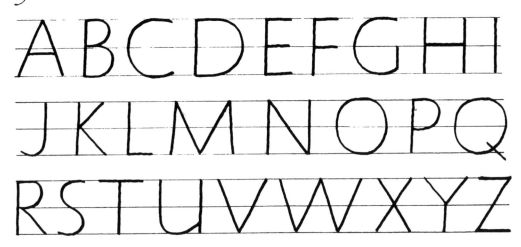

ABCDEFGHI
JKLMNOPQ
RSTUVWXYZ

Stage 1

The alphabet may be divided up into families based on proportion.

Letters based on a square are:

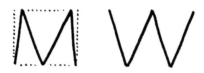 Note that the legs of M are slightly splayed. W is a little wider than M.

Letters based on 3/4 of a square are:

HAUNTV

Letters based on ½ of a square are:

BPRS,EFLKJ

Note the slight differences of the upper parts of B P R, and E F in relation to the centre line.

Letters based on 5/8 of a square are:

XYZ

Letters based on a circle:

CDGOQ

In practice those proportions may be exaggerated but at this stage, follow the above closely.

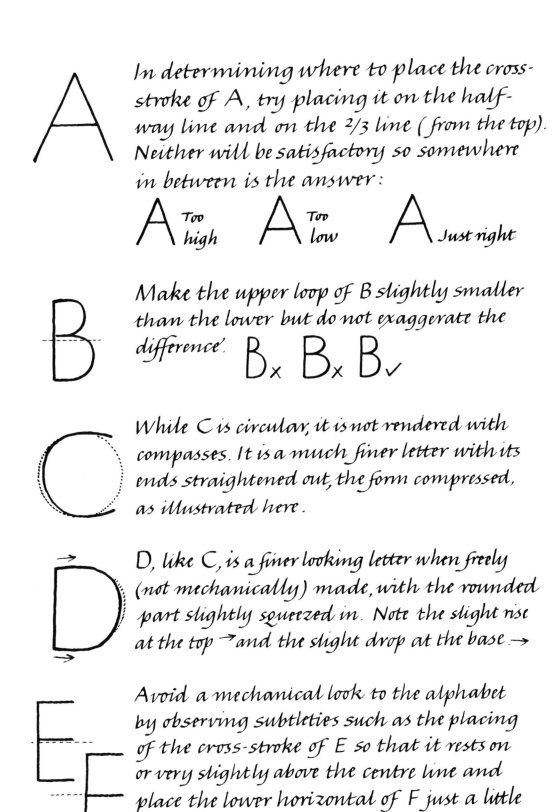

In determining where to place the cross-stroke of A, try placing it on the half-way line and on the 2/3 line (from the top). Neither will be satisfactory so somewhere in between is the answer:

A Too high A Too low A Just right

Make the upper loop of B slightly smaller than the lower but do not exaggerate the difference. B× B× B✓

While C is circular, it is not rendered with compasses. It is a much finer letter with its ends straightened out, the form compressed, as illustrated here.

D, like C, is a finer looking letter when freely (not mechanically) made, with the rounded part slightly squeezed in. Note the slight rise at the top →and the slight drop at the base.→

Avoid a mechanical look to the alphabet by observing subtleties such as the placing of the cross-stroke of E so that it rests on or very slightly above the centre line and place the lower horizontal of F just a little lower. Make all the arms equally long.

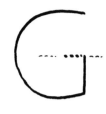

G is just C with the addition of the vertical stroke which reaches up to the half-way line. It is not necessary to add a horizontal stroke to the vertical one but this is permissible: G.

H is simply two vertical strokes, linked with a horizontal one which is placed to rest on the centre line or a suspicion above it, like the centre stroke of E.

I is, of course, the simplest letter of the alphabet and J is almost as simple but for the turn at the base which should be straightened out slightly. It must not look like an upturned walking stick.

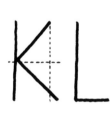

K is another letter which requires care particularly in the drawing of the chevron ⟨ The lower part should protrude a little more than the upper to give the letter stability. L is simply E without the upper arms.

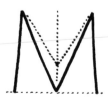

M is comparatively difficult to do well, as the legs require to be splayed slightly & the V part made so that it just touches the base line. An alternative V is shown as a dotted line.

The down-strokes of N are vertical and spaced equally to those of H. In old carved inscriptions the diagonal is often found ascending ! – И.

O and Q are identical except for the tail of Q which may be made as a stroke cutting the letter or as a stroke branching off from the line. The dotted line shows the extent the letters are compressed from a true circle.

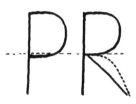

P and R are another pair of near identical letters but for the addition of the leg to R which may be rendered in alternative ways as indicated. Note the difference in the loops.

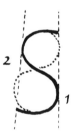

S is a particularly difficult letter to produce. It is basically two circles, the smaller atop the larger, with parts cut away and the ends straightened out. Note the vertical nature of the tangent to the lower part (1) and the slope to the right of the tangent to the upper part (2).

T is another very simple letter consisting of a vertical stroke capped by a horizontal, making the letter equal in width to HAN.

U is the same width as T. Note the flattened off nature of the first down-stroke as it joins on to the second down-stroke. It may also be made as a continuous down, round and up letter as indicated by the dotted line.

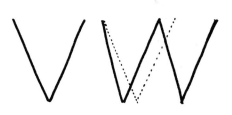

W is really a double V (not double U !), but the V's are slightly narrower than the single V whose width is the same as A.

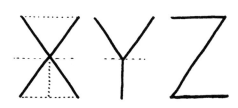

XYZ are all equally wide and conveniently coincide one with another, providing another example of the way the alphabet economises in stroke and form.

The alphabet arranged in family groups:

EFL·HIT·CGOQ

DBPR·KXYZN·J

U·AVWM·&S

12

ABCDEFG
HIJKLMNO
PQRSTUVW
XY&Z

Here is the alphabet now produced with contrasts of stroke, the effect of using a LETTERING PEN with a chiselled point. Those nibs vary in width from very fine to as broad as an inch or so and as it it is very important to know how to hold this pen & to manipulate it properly, here are points to remember:

1 Hold the pen between thumb & fore-finger and support it behind with the middle-finger.

2 Point it on to the paper at an angle of 45° or so and also at an angle of 45° to the writing line.

3 Now try to produce those patterns. If the pen is being held properly the horizontal & vertical strokes will be equal in width.

XXX+++OO

Stage 2

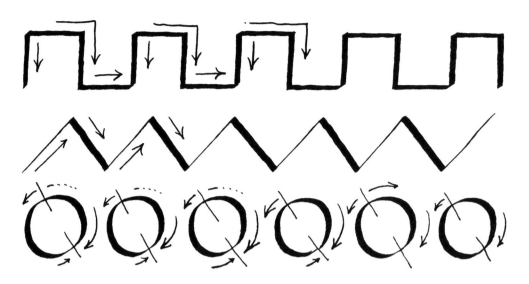

If you can reproduce the above patterns exactly as
you see them here you are obviously holding your
pen properly and should, therefore, have no difficulty
with the Capitals which now follow. But when
using the broad or 'edged' pen, one must always
remember to pull all strokes, as pushing the pen
can lead to the pen spluttering, through catching
it on fibres if the paper surface happens to be rough.
Try copying the capital alphabet following the
stroke directions as indicated.

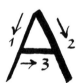 If the pen is at the proper angle, three
distinct widths of stroke will be got
in making A.

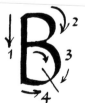 B is a four-stroke letter. If the first stroke
is continued so as to eliminate the
fourth one, then it could be a three-
stroke letter: ⌊₁ \₃.

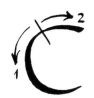 Just as it was recommended in our Stage One alphabet so do not make C like a circle partly cut away. Straighten out the top slightly.

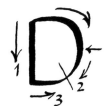 And avoid a mechanically-made look to D by making stroke two rise slightly. Compress the arrowed part a little.

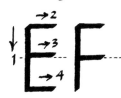 Let the centre-stroke of E rest on the half-way line and place the lower horizontal arm of F, so that the half-way line bisects it.

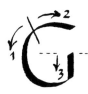 G, like C, is also compressed laterally. The vertical stroke may be capped G̅, or left without as here.

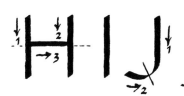 The horizontal stroke of H rests on the half-way line. Note the flattening of the base-stroke of J.

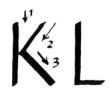 So as not to make stroke two of K too thin alter the pen-angle from ↖ to ↑. Let stroke three protrude slightly.

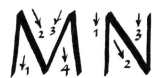 Splay the legs of M slightly. Alter the pen-angle of strokes one and three of N to make them thinner, to contrast with stroke two.

15

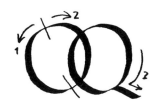 As with C G D, those letters are compressed laterally. The tail of Q attaches to the thinnest part of the letter.

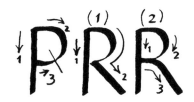 Do the loop of P in two strokes, but do the loop and 'leg' of R1 in a single stroke.

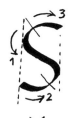 Consider S as springing from two circles the smaller atop the larger. Do the centre stroke first, the base next & the top as the final one.

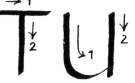 T and U are equal in width, fitting into 3/4 of a square.

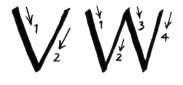 W is made up of two compressed V's. Take care not to make strokes 2 & 4 too thin, by altering the pen angle to give a thicker stroke.

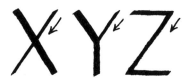 This also applies to the arrowed strokes of X Y & Z.

Practise the alphabet in this manner:

ABABAB · ADADAD
ACACAC · AEAEAE

abcdefghij
klmnopqrst
uvwxyz

The Small-letter
alphabet should be made first in skeletal
form, using pencil, fibre-tip or felt pens and
then with the broad-edged lettering pen.

abcdefghij
klmnopqrst
uvwxyz

Note well!
This is a simple alphabet – but far from easy to do well!

Stage 3

The Pen and Letter-
HEIGHT

The weight of the letter is determined by the number of pen-widths which go into the x-height Here are examples which show the average letter-height and the result of using fewer or more pen-widths in rendering Small-letters & Capitals.

a b g AbC

5 pen-widths, 9 9, 7, 9, 7.

The above illustrate the average heights : five pen-widths for the x-height, nine for the ascender letters and also for the descenders. The capitals are seven pen-widths tall. To create a lighter or darker effect, increase or decrease the number accordingly.

a b g AbC

7 pen-widths, 12 12, 9, 12, 9.

a b g $AbCdEFG$

3 6 6 5 6 5 6 5 6 5

Note the height of capitals to small-letter ascenders.

18

As has already been stated, this alphabet, although described as a simple one, is by no means as easy as it looks and requires skill to do it at all well.

The pen must be held at an angle of 45° to the writing line and held at this angle for every stroke.

And the pen must be manipulated by the hand and not by the fingers if we wish to achieve uniformity of form & slope in the letters.

The alphabet is founded on the circle — almost 'ring and stick', one might say. But this does not mean that the rounded parts are perfect circles. a d g & q are made with C joined on to a vertical stroke — the top part (⌐) joining on to the vertical at an angle of almost 90° b and p are true inversions of d and q.

Practise:

abababa

pdpdpdp

19

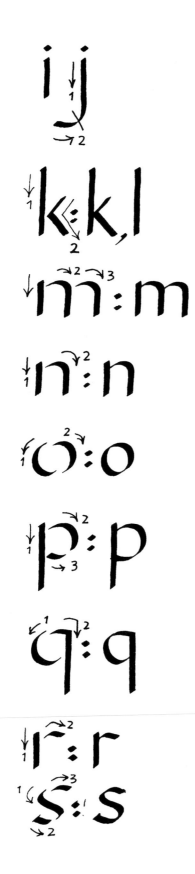

Other subtleties are to be found throughout which prevent the alphabet from being a mechanically contrived thing and which no doubt account for the difficulties one encounters. Straightening off the turns to the downstrokes of g and j, ensuring that the arches of M and N and the base of U are rounded properly, the proper fitting of loops to verticals as in a, d, g, q, b and p and realising well-executed r's and s's, are all challenges to one's skill. Practising the following exercises will enable one to acquire sufficient mastery:

cicicicicicicicici
lblblblblblblblbl
jfjfjfjfjfjfjfjfj
rsrsrsrsrsrsrs
mumumumumu
oeoeoeoeoeoe

t, u, u, u

v, w

x, y, z

When one considers the elements comprising the alphabet, it is, indeed, a very remarkable achievement:

a b o n u
x z

Here is an exercise for you to try out, involving the alphabet and the spacing out of the letters.

a
b c d
e f g h i
j k l m n o p
q r s t u v w x y
and
z

You may try this first by tracing over my letters and then doing your own, in your own way.

This exercise will also provide you with an opportunity to use two colours &

to create interesting effects in various and contrasting ways. Be creative!

21

A simple Italic Small-letter alphabet

is distinguished by the slight slope to the right and by the compressed nature of the letters when compared to the more rounded character of our first small-letter alphabet which was founded on the circle, whereas the oval is the basic form of Italic

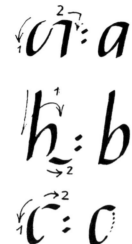

The pen must be manipulated by the whole hand (not the fingers!) to get the proper tilt of the letter. Without its ascender, 'b' is simply 'a' turned upside down. Always keep the oval foundation in mind! (see C).

Render 'a c d e g q with a fairly straight back.

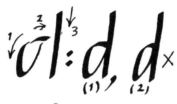

Do not make the Italic letters too compressed as in example 2.

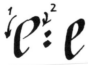

The italic e is made in two strokes, the first being c to which a loop is added ᵓ: e.

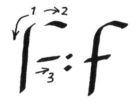

For this alphabet do not make f a descender letter, and give the cross-stroke a slight upwards slope.

Stage 4

g : g

h : h

i, j : j

k : k, l

m : m, n

o : o

p : p

q : q

r : r

s : s

t : t

u : u

v : v

w : w

x : x

y : y

y : y

&

z

23

abcdefghijkl

Very often the "small - letter" Italic is pair-

mnopqrstuv

ed with the sim-ple Roman Capital as

here – but WXYYZ note the

height of capitals to the ascender letters.

aAbBcCdDeEfFgG

hHiIjJkKlLmMnN

oOpPqQrRsStTuU

vVwWxXyYzZ

Note the
height of
Capitals. aAbBc to the
ascender
letters.

24

A simple Italic Capital Alphabet

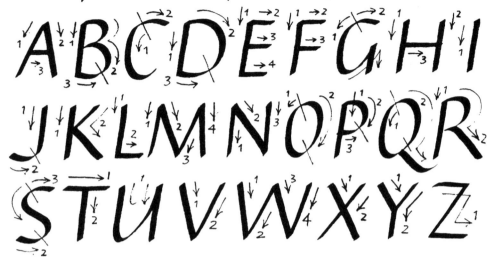

ABCDEFGHI
JKLMNOPQR
STUVWXYZ

The Capitals slope simi-
larly to the Small-
letters & the
round
letters
become
oval

in form. Pen-angle is
also altered on
occasion e.g.
for the
down-
strokes
of N.

A B C D
b c
f E F G H g
 e i j h
i k L M N
q j n p
O P Q R S T
r s t u x y
U V W X Y &
 v & z
Z

An alphabet 'fruit-tree' is fun to do. Try one!

SPACING

letters so that one's eye can automatically judge the correct distance the letters should be from each other, requires much practice. Placing letters the same distance apart leaves some with conspicuous gaps between and others so close to one another that they have 'no room to breathe'!

SPACING

Now, by arranging the letters so that equal areas of space surround each of them a much more unified effect is obtained:

SPACING

Fine adjustments may have to be made until one is finally satisfied. It helps to examine the word, the paper turned upside down.

SPACING

Round letters together should be close : OG,OO
Vertical letters should be further apart: IN,HI
Vertical next to round letters will be something in between: NG. Note PAC !

SPACING WORDS AND LINES

should present little difficulty if the following rules are remembered :

For ease of reading, words should be separated by a letter space (say n)

a·stitch·in·time·saves nine

The Romans separated words with a spot. This is sufficient!

Lines should, for maximum legibility, be separated so that the descenders of one line do not overlap the ascenders of the next line. But many calligraphers do not observe this rule too religiously. They bring lines very close together— to give a densely packed effect, or spread lines out in order to allow ascenders & descenders to be elongated for decorative purposes.

Here ample space has been left between lines. This is ideal for all ordinary purposes where legibility is of prime importance.

Lines should be far enough apart for ascenders and descenders not to overlap.

ENTRANCE

Practise writing out little signs &

EXHIBITION

notices like these to help you to

NO PARKING

space letters. The more you prac-

CHILDREN

CROSSING

tise, the more readily your eye

PAY HERE

will judge exactly where to place

NO SMOKING

your PLEASE *letters.*

Aberdeen and

Here
are a
few place-
names for
you to copy.
The same rules
for spacing apply
to the small letters
as to capitals but

Brisbane

Note the
overlaps
of be &
ba.

Calgary

Denver

Edinburgh and

there
are times
when you
may wish to
economise on
space so you can
overlap round
letters as I have,
with b and e, b &

Folkestone

Geelong

Hartford

a. Other occasions for this are: oo, og, oc, oe, oa
and, of course, double t : tt. This is a perfectly legitimate
thing to do but only when necessary. Do not overdo it!

oe, oo, oc, og, oa, tt.

EXHIBITION
of painting and calligraphy

~~~~~~

# KIRKCALDY
## Art Gallery

~~~

March 1 to 15 1977

IN the beginning God created the heaven and the earth. And the earth was without form and void ; and darkness was upon the face of the deep. And the spirit of God moved upon the face of the waters. And God said, Let there be light : and there was light. And God saw the light, that it was good : and God divided the light from the darkness. And God called the light DAY and the darkness he called NIGHT.

The Simple Italic alphabet is here used as a book letter—
its simplicity, almost amounting to austerity, imparts
a 'modern' look to the page. Note the elongated ascenders
and descenders.

31

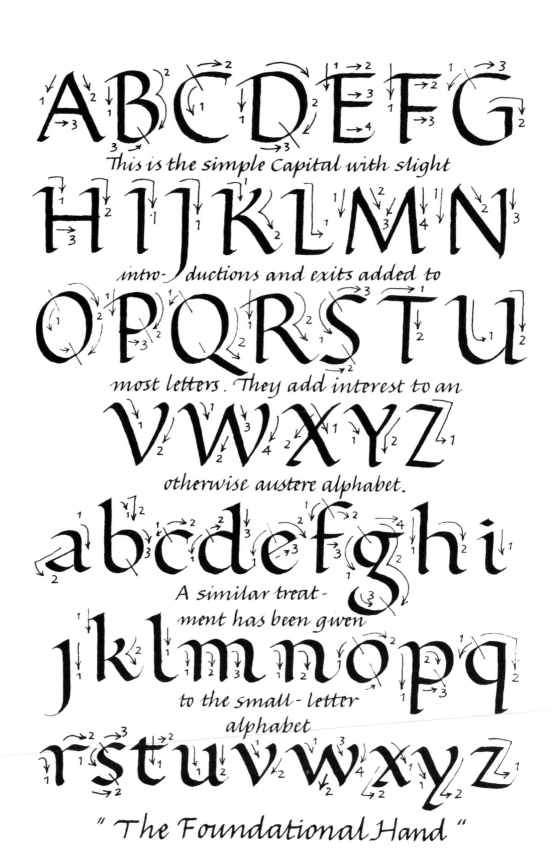

This is the simple Capital with slight intro-ductions and exits added to most letters. They add interest to an otherwise austere alphabet.

A similar treat-ment has been given to the small-letter alphabet

" The Foundational Hand "

OUR FATHER

which art in heaven, Hallowed
be thy name. Thy kingdom come.
Thy will be done in earth as it is
in heaven. Give us this day our
daily bread. And forgive us our
debts, as we forgive our debtors.
And lead us not into temptation,
but deliver us from evil; For
thine is the kingdom, and the
power and the glory, for ever,
AMEN

St Matthew. Ch.6

Try copying this paying attention to the spacing of letters, words and lines.

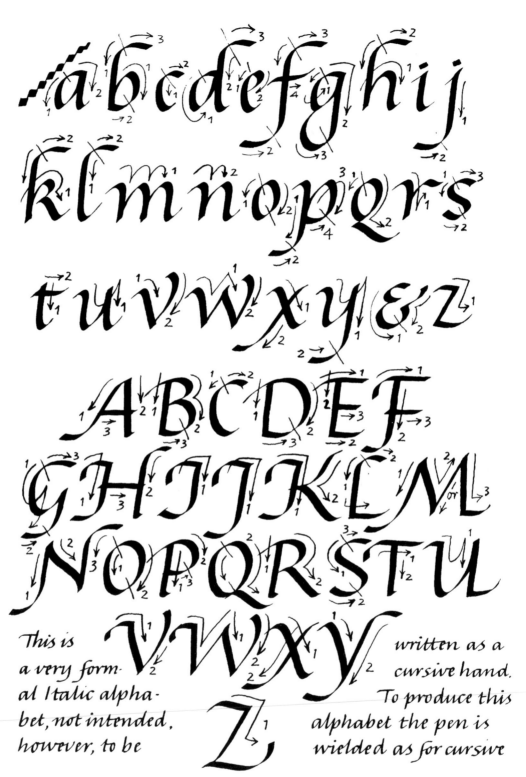

This is a very formal Italic alphabet, not intended, however, to be written as a cursive hand. To produce this alphabet the pen is wielded as for cursive writing otherwise the 'swing' you see here will not materialise!

Proverbs for Practice

Short sentences, — such as the following offer excellent practice. Try to obtain a sense of rhythm into your writing and begin by tracing. Two sizes of nib were used here.

A stitch in time saves nine.

Look before you leap.

Many hands make light work.

Pride goes before a fall.

Empty barrels make most noise.

All that glisters is not gold.

Speech is silvern, silence is golden.

Good gear goes into small bulk.

Waste not, want not.

THE RVSTIC CAPITAL

was a book hand of antiquity and the Pompeiians were also accustomed to see it on the walls of buildings, announcing meetings in the forum and other public messages — classical sgraffiti ! The reed pen was used — held almost horizontally ← — and it was obviously an alphabet intended for economy of space as it is so compressed, as well as for speed since the strokes are so simple and direct.

ABCDEFGHIJKLMN

See alternate I & J

OPQRSTVWXYZ·IJ

The pen is held almost parallel to the writing line.

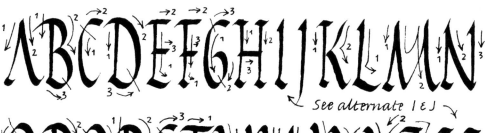

POMPEII·TIMES
JVLIVS·CAESAR
MVRDERED —
LATEST

The stroke narrows gradually as the pen descends.

Here the pen angle has been altered as the stroke descends. The Rustic capital is a pure pen-formed alphabet.

PATER·NOSTER

QVI ES IN CAELIS·SANCTIFICE-
TVR NOMEN TVVM·ADVENIAT
REGNVM TVVM·FIAT VOLVNT-
AS TVA SICVT IN CAELO·ET IN
TERRA·PANEM NOSTRVM SVP·
ERSVBSTANTIALEM DA NOBIS
HODIE·ET DIMITTE NOBIS DE-
BITA NOSTRA·SICVT ET NOS
DIMITTIMVS DEBITORIBVS NOS-
TRIS·ET NE NOS INDVCAS
IN TENTATIONEM·SED LIB-
ERA NOS A MALO· AMEN.

Try this as an exercise. Do not aim for mechanic-
al perfection of every letter!

THE UNCIAL and half uncial alpha- bets

The Uncial and half-uncial styles originated many hundreds of years ago and are a true product of the broad-edged pen which was then, of course, the quill. To produce those alphabets the pen should be held fairly vertically. ↑

As can readily be seen, the letters are based on the circle and on the simplest & most direct pen-strokes.

Pen angle & elements lloanuxs

the quick brown fox jumps over the lazy dog

This is an example of a modern half-uncial, modified in quite a few ways from the 7th and 8th centuries half-uncial for present day use.

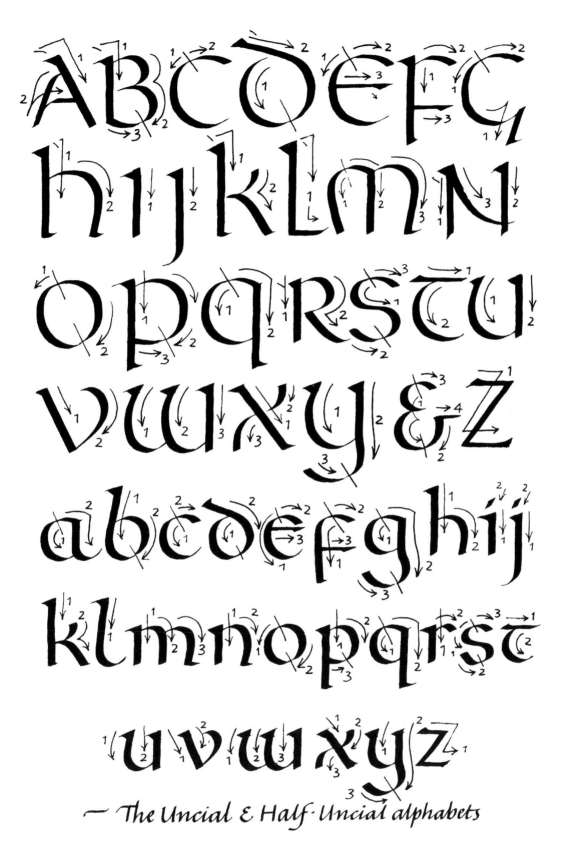

~ The Uncial & Half-Uncial alphabets

Historically the
GOTHIC ALPHAbets
followed the
Carolingian or Round
Hand alphabets

and as can readily be seen, there is a marked contrast between them, the Gothic being angular and, therefore, compressed, in contrast to the rounded and open character of the Carolingian. To one unaccustomed to it, Gothic lettering is much less legible but this is no doubt due to the fact that we are not confronted with it every day.

Even so there is no denying that the Carolingian hand is the more easily read of the two and its letter forms much more pleasing.

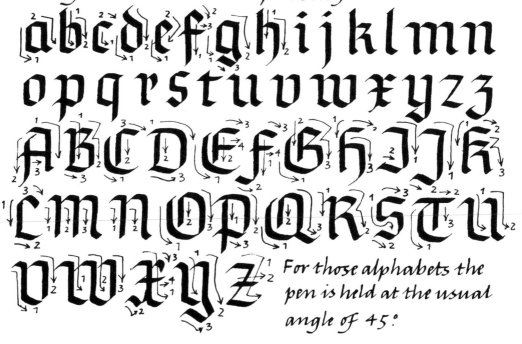

For those alphabets the pen is held at the usual angle of 45°.

A free, less angular, GOTHIC

with some cursive characteristics is the next stage.
The angles are softened and the movement of the hand
is allowed to dictate the letter forms rather more.

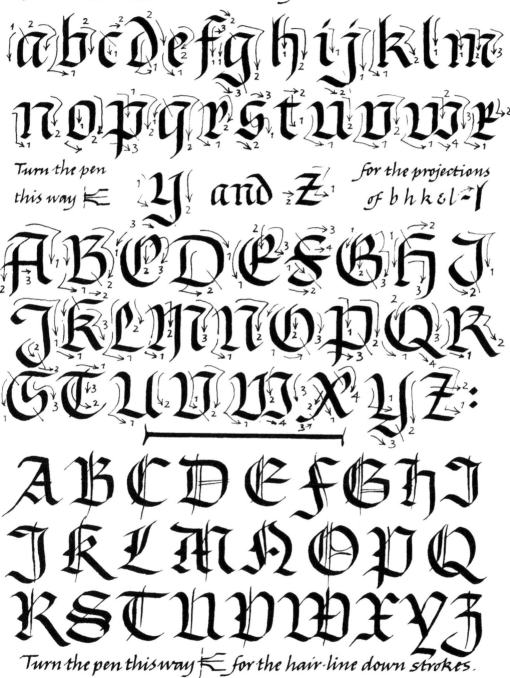

Turn the pen this way ◁ for the projections of b h k & l

Turn the pen this way ◁ for the hair-line down strokes.

41

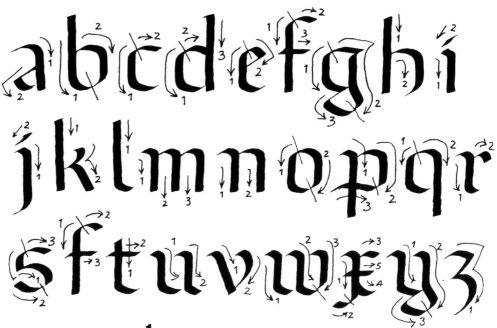

Rotunda

Rotunda or Round Gothic, was favoured in Southern Europe, notably in Spain, Portugal and Italy. It is a beautifully clear and simple alphabet but although simple, it is not easy. For this alphabet the pen is held pointing to the writing line almost at right angles and the angle has to be changed for n m h i k p q to give the down-strokes flat bases.

l m h k p q f n

The pen is now pointing ⟍⟍⟍⟍⟍ at right angles — ⋀ — to the writing line

ab

This is the size of letters often found in Southern European manuscripts, mostly from church music books. As a capital alphabet for Rotunda, a simple Uncial is suggested

ABCDEF

abcdefghijk
lmnopqrst
uvwxyz

The Italian *Humanist scribes followed the Rotunda with a version of the Carolingian minuscule (small-letter) which was so mechanically perfect that it resembles type. The above is a modern adaptation, written out here with a* <u>broad</u> *pen – the original alphabets were much lighter in texture! A home-made bamboo pen was used here.*

ABCDEFGHIJ
KLMNOPQR
STUVWXYZ

For both alphabets the pen-angle is flatter than the usual 45°. The capitals are not so tall as ascenders.

Cursive Italic ~ the handwriting for today.

The text of this book is written in a modern Italic hand — a style based on the XVth- XVIth centuries Italic, but obviously simplified to make it more practical. For this style of writing an edged pen has been used, similar to the lettering pens we have been using — but very much narrower.

The elements: *n u · v a · o · x*

The alphabet in families :

m – nmr · hk · bp

uu – itl, uvwy, adgq,

oec, fjs, xz

a b c d e f g h i j k l

ab cdefg hi ijkl lmn

m n o p q r s t u v

nopqurst tu uvwxyɛz

w x y z tt · ll · ff · ss · d ᶞ

Aama Bbmb Ccmc Ddmd
Eeme Ffmf Ggmg Hhmh Iimi Jj
mj Kkmk Llml Mmnm Nnmn Oomo
Ppmp Qqmqu Rrmr Ssms Ttmt U
umu Vvmv Wwmw Xxmx Yymy
and Zzmz

The above illustrates both alphabets and all the joins
and pen-lifts which should be practised again and
again until the technique becomes automatic.
Pen lifts occur before a c d g q, f & z and
 after b g j p q s x y
 but where double b, p and s occur,
 join from the second letter of the pair:
 abbey, apple, assess.
 e is written as a single stroke letter, e,
 when beginning a word or after a pen-
 lift, otherwise it is written in two strokes

abcdeffghijklmnopqursst
tuvwxyy and z.

This is a formal cursive Italic for special
occasions such as for writing out wedding
invitations, birth announcements & so on.
Many more pen-lifts are required for it.

The President,
Lady Cholmondeley,
invites you to a
SILVER JUBILEE PARTY
of
The Society for Italic Handwriting
on Friday, November 25, 1977
at
Kensington Palace Gardens
W8

R·S·V·P
The Secretary,

7·00 pm
Informal.

Examples of an invitation & personal stationery

Tom Gourdie, M·B·E· S·S·I· D·A·
Handwriting Consultant,
Calligrapher, Author &
Artist
3 Douglas Street, Kirkcaldy,
Fife, Scotland. Kirkcaldy
4431

With compliments
Tom Gourdie, M·B·E·,
Calligrapher
3 Douglas St, Kirkcaldy, Scotland.

46

THE VERSAL

CAPITAL is made by a narrow lettering

pen, the thick strokes being made of lines tapering into the
waist. The curved parts are made with two strokes, the inner
being rather flattened. (()). The pen is held this way ↑ for the
down strokes and in this way for the horizontal strokes ←.

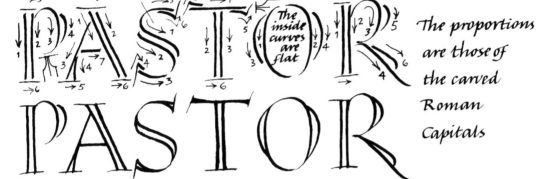

The proportions
are those of
the carved
Roman
Capitals

PASTOR

The Versal was used originally to begin chap-

ters or verses. It is also effective en masse, used decoratively:

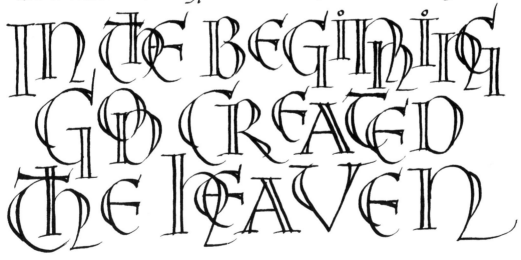

This is an example of the decorative use of Versals.

Stage 13

ABCDEFG
HIJKLMN
OPQRSTU
VWXY&Z

The Versals may be left as lines or filled in as you see here.

ABCDEFGH
IJKLMNOP
QRSTUV&
WXYZ

the decoration must not detract from the letter but complement it.

48

ABCDEFGH
IJKLMNOP
QRSTUVW
XYZ

This Roman Alphabet is known as the Trajan Roman but the letters J K U W Y Z were not included in the original inscription which is to be found on the monument erected in Rome in 114 A.D. in honour of the Emperor Trajan. This alphabet with its beautiful proportions is considered the finest achievement in carved lettering in the Roman style.

The Elements

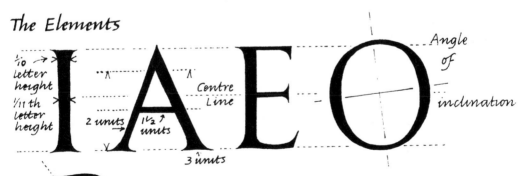

The alphabet was originally inspired by the chiselled reed hence the disposition of 'thicks and thins' & the angle of inclination of the round letters. It is by no means a mechanically contrived thing.

49

Stage 14

A

The width of A is slightly more than 5/6 of the height. The wide stroke is 1/10 of the letter height. The left hand stroke is 2/3 of the wide stroke. The cross stroke is 1/2 a wide stroke and lies midway between the inside angle at the top and the base line.

B

The proportion of the upper loop to the lower is 5:6 (approx.). Lines are drawn at the thickest parts of the loops. The thin parts * are less than half a wide stroke.

C

The outside curve is part of an almost perfect circle. The inner curve is slightly tilted to the left. The upper serif is slightly heavier than the lower. A vertical line connects the outside limits of the serifs.

D

The outside curve of D, like that of C, is almost a circle. The thin parts are less than half a wide stroke. Like the other round letters it is made to overlap the guide lines very slightly.

E

This letter is almost half a square. The middle arm rests on the centre line. The vertical line connecting the upper and lower serifs shows the mid-arm to be a little shorter than the others.

Centre Line

F

F is much the same proportion as E but the upper arm is slightly longer than that of E. The lower stroke of F is bisected by the centre line. The arms of E and F are approximately half as wide as the wide stroke.

Centre Line

G

The letter G is similar to C in structure but has in addition an upright tail which here comes up almost to the centre line.

Centre Line

H

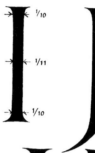

The proportion of width to height is here 7:8. The horizontal bar which is half the width of the vertical strokes rests on the centre line.

C.L.

I J

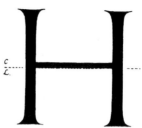

As with all vertical letters (B D E F I L P R T U and K), the sides of I and J are slightly concave, being 1/10 of the letter height at the extremities and 1/11 at the centre line.

1/10
1/11
1/10

K

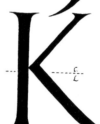

The width of K at the top is approximately 2/3 of the letter-height but the width at the base almost equals the height. The thin diagonal stroke is here half a wide stroke in width and half the width of the lower diagonal.

C.L.

L

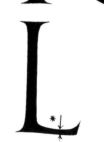

The horizontal arm is half the letter height and is the same length as the base of E. Its width * is half that of the vertical or wide stroke. The subtle ogee curve to the base is common to both E and L.

M

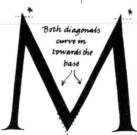

Both diagonals curve in towards the base

The legs of M splay slightly from the vertical. Do not overdo this.
The first and third strokes are 2/3 of the width of the second and fourth strokes. The upper points * project above the line 1/4 of a wide stroke.

N

The proportion of width to height is 7 : 8. The vertical strokes are 3/4 of the width of the diagonal stroke. Note how the apex extends above the line and how the diagonal curves towards the base.

U

The width of U is 7/8 of the height. The left-hand stroke tapers to a point to touch the right-hand vertical stroke. The serif at the base has been tilted up slightly.

O Q

O is slightly less than a circle in width. The outside curve is perpendicularly symmetrical but the inside one is tilted. Q is similar to O, but for the tail.

V

In the Trajan Column inscription this letter is a little wider than 'A' but whereas the oblique strokes of 'A' are straight, those of 'V' curve towards the base, making the point rest on the line.

P

P fits into half of a square. The outside curve of the loop is quite circular. The loop comes below the centre line 1/2 of the wide stroke. Note the gentle rise of the loop from the top of the vertical stroke.

W

'W' is made up of two 'V's crossed on the centre line. The oblique strokes curve towards the base, as with 'V'.

R

The loop of R is deeper than that of P, coming the width of a wide stroke below the centre line. The tail is placed in line with the upper serif and the loop tends to straighten towards the junction* to enable the tail to join the loop almost at right angles.

X

The width of 'X' is 7/9 (approx.) of the height. The narrow stroke is half of a wide stroke in width.

S

The letter S seems to have a forward tilt but this is due to the lower part being slightly larger than the upper, and the serif at the top being vertically in line (like a tangent) with the lower curve. The letter is built up of two circles.

Y

This example is 7/8 of a square in width. The narrow stroke is half of a wide stroke in width. The upper arms branch from the centre line.

T

The proportion of width to height is 7 : 9 (approx.). The cross stroke is 2/3 of the width of the wide stroke. The angle of the serifs varies slightly, the one on the left tilting rather more. The cross bar also tilts down a little to the right.

Z

The width of this example is 3/4 of the height. The upper arm is horizontal – the lower one has a tilt similar to the base strokes of E and L. The top of the diagonal stroke has a slight curve and the upper serif has been turned in slightly towards the letter. *

ABC DEFGHIJ KLMN OPQRST UVW

Note the alternative form of W.

XYZ

Here is another example of an alphabet tree, designed to give you practice in the

Roman capital. Here it has been rendered in various sizes. Try designing one of your own.

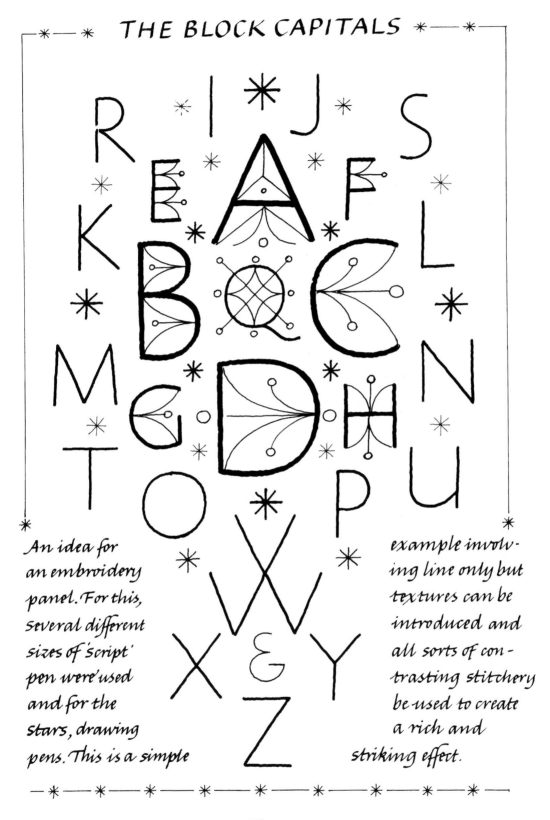

An idea for an embroidery panel. For this, several different sizes of 'script' pen were used and for the stars, drawing pens. This is a simple example involving line only but textures can be introduced and all sorts of contrasting stitchery be used to create a rich and striking effect.

Duncan of Jordanstone
College of Art

DIPLOMA

The Governors of Duncan of Jordanstone
College of Art, authorised by the
Scottish Education Department,
CERTIFY that

successfully completed the Diploma
course of study in

and fulfilled the conditions required
for the award of the Diploma

Chairman

Principal

Head of School

This is an example of an asymmetrical
design for a Diploma in a formal Italic
style. In this, only four different sizes of
letters have been employed. Names and
courses were added in red.

Two Diploma designs, one asymmetric and the other symmetric
in layout. Both feature the formal Italic hand.

BE IT KNOWN

PATRICK HORSBRUGH

shall henceforward be acknowledged

by the style of

ECO

signifying his membership of the

Most Essential Order of Ecouleegia

in recognition of his efforts towards the

promotion of ecological, economic & ecosystematic

comprehension of environic qualities in general,

and their several particularities,

Cultural, Ethical & Natural,

determined this day of

This is an example of a symmetrical design. Begin
with a line drawn down the centre and ensure that
each line is centred. If the text is written out asym-
metrically first of all this gives one the length of
each line and the rest is straightforward.

Aegre de Tramite Recto

Tom Gourdie

55

Try making a decorative panel of Capitals — spontaneously. You may have to do quite a few to get a reasonable one.

A B C D
E F G H
I J K L M
N O P
Q R S
T U
V W X Y Z.

THE FINNISH DESIGNER
Tapio Wirkkala
who was responsible for
the planning of the

FINNISH PAVILION
at the
1958 BRUSSELS EXHIBITION

has been awarded the

S.I.A. DESIGN MEDAL
1958

These two posters represent the calligraphic poster (and brush lettering) at its best and are the work of the late Pamela Barnett whose calligraphy for Heal's of Tottenham Court Road brought international acclaim.

a collection of new

Scandinavian Furniture

including the newest
DINING & LIVING ROOM DESIGNS
from

Norway
Sweden
Denmark

Mansard Gallery · this floor

AUGUST 20. – SEPTEMBER 20.

Calligraphic poster by Pamela Barnett.

1234567890
1234567890
1234567890
1234567890
1234567890

Numerals: This is a page from The Puffin Book of Lettering which, although originally intended as a text-book for children, has proved to be as much a text-book for adults. This book was the first of my books to be written by me, and then the whole designed and carried out as a calligraphy project, in the manner of the early Italian Writing Masters.

It is my hope that you, the newcomer to the craft, may be sufficiently encouraged by a study of this book to enjoy many happy years devoted to such a rewarding pursuit!